IN RUINS

IN RUINS

THE ONCE GREAT

HOUSES OF IRELAND

Photographs by Simon Marsden

Edited and with text by Duncan McLaren

Introduction by P. J. Kavanagh

Collins

ST JAMES'S PLACE, LONDON

1980

To Carrie and Minnie

I came on a great house in the middle of the night,
Its open lighted doorway and its windows all alight,
And all my friends were there and made me welcome too;
But I woke in an old ruin that the winds howled through;
And when I pay attention I must out and walk
Among the dogs and horses that understand my talk.
> *O what of that, O what of that,*
> *What is there left to say?*

FROM ''THE CURSE OF CROMWELL,'' W. B. YEATS

The houses and castles in their counties

Introduction by P. J. Kavanagh

There is nothing sad about ruins, oddly enough, unless we want to make them so. On the contrary, there is something cheerfully uncorseted about them, a sense of release. Now there is no more worry about underpinning, shoring them up, keeping them in shape. At last the building is no longer plumped four-square onto the landscape, an effort of will constantly in need of renewal (which so often proved too much for the heirs, who gambled or drank it all away). Now these houses, as the photographs show in such a special fashion, have become what they always wanted to be, a part of the landscape itself.

Of course, we can make ourselves feel a sadness if we want to. We can recollect ourselves and try to people the deserted ballroom with ghostly dancers, the arrow-slits with bowmen, the overgrown drive with painted dog-carts. But we never really see them. The ruin itself is too strong in its new-found contentedness. It is not the swish of crinolines that we hear, or the sound of bolts released from crossbows, rather it is the swish of the tangled ivy that nearly fills the glassless windows, the sigh of wind in the ruined chimney, the barking of a distant dog. We remain in our present, enhanced, made more sharp, by the past that surrounds us.

This, I take it, is the real pleasure of ruins: a delight in the way that nature, of which we are a part, has had her way at last and nobody could do anything about it. A delight also that nature (as these photographs prove) has made the building even more beautiful than it was when wealth, greed, war-prowess, or sheer dogged determination kept the whole show going.

This pleasure, this release, is what children sense at once, whooping up the ruined steps, straddling battlements, rolling in the dry and harmless moat. Children and mice and owls and every kind of herbage come into their kingdom and (above all in Ireland) so does every trick and change of the light. The sun dramatises these ruins, its sudden withdrawal even more so.

The truth is that most of these places should not have been there anyway. They are a fluke of history, of the eighteenth-century wealth of England and the artificially imposed poverty of Ireland.

Non-Roman, non-Saxon Ireland, where "the air alone makes one do unexpected things," absorbed the new Irish and changed them. They came for cheap land, cheap labour, cheap status, and they found all these things. It must have seemed a paradise, and for some it was. But the Irish temperament, with its wholly different order of priorities, its subtle potency (not nearly as "comic" as English caricature began, rather fearfully, to pretend), entwined itself round the new landowners' minds and hearts as the creepers now entwine themselves round the remains of their magnificent houses. Thus was born the special case we call today "the Anglo-Irish." They were dependent on the English connection for their lands and wealth. But as the years passed the influence of their surroundings soaked into them: surroundings which to this day are almost Oriental in their strangeness, despite their deceptive similarity to England. They no longer knew which side they were on, the head or the heart. It is no accident that we owe some of our greatest writers of the period to them—Burke, Sheridan, Swift—or that the leaders of every Irish revolt from the eighteenth century to the twentieth were for the most part drawn from this bewildered class.

The life in most of the houses here portrayed only flourished for a short while. The new landowners, embedded in their apparently perfect life, seemed to lose heart almost at once. Terence de Vere White, who wrote a book about them, says that as early as 1800 their diaries bear a resemblance to General Gordon's when he was waiting for the Mahdi at Khartoum. More and more they began to seek their pleasures in England, regarding their vast Irish properties "as if they were estates in Basutoland." They still collected their rents of course, or had them collected by agents, almost universally detested.

Today parts of these estates are bought up by new lovers of all

things Irish, who become equally disheartened. Kate O'Brien tells of watching one of these grow increasingly exasperated as he had his car loaded with purchases in a quiet village street. "No!" he shouted, "not there you fool, *there!* Do I have to say everything twice?" and so on. She became angry at his hectoring until she caught the eye of the shopwoman, who was smiling. "He seems annoyed," the woman said. "You know, when I hear them kicking up against us like that, I say to myself that so far as I ever heard no one ever sent for them."

Indeed. No one ever sent for those earlier settlers—though many were sent, with huge grants of Irish land—and they must have been similarly maddened by that easy tolerance, easy superiority, deriving from roots they did not share and did not understand, which watched the new masters as though they were descended, briefly, from the moon.

The artless captions to these photographs, the memories of a bystander, filled with ghosts, murders, and lordly goings-on, catch some of this wonder and indifference.

"A little bit of Heaven dropped out of the sky one day," says Tin Pan Alley, and there is something celestial about parts of Ireland in certain lights. It is difficult to blame the grandees for wanting to make bits of it their own. Perhaps they were baffled in this, as much as by anything, by Irish contradictions. Kate O'Brien tells another story, of the Italian novelist Ignazio Silone who had been staying with her in Connemara; he was enchanted, dazzled, as I never heard of a visitor who was not. She saw him off at Galway Station, which was being refurbished. "You've given us fourteen days in a Japanese paradise," he said. (The Orient again!) "We say good-bye at a junction in West Poland."

It was inevitable, for these big-house dwellers, that the dream of the good place should die, for it was based on nothing substantial. Their houses, imposed on a peasant Ireland, had no choice but to become a part of the land itself, as apparently old and welcome as the aboriginal rocks. In these photographs, in the manner of their developing and printing, we see this taking place. They are the record of a natural, one might say triumphant, process. As W. B. Yeats said (for all his "Irishness," a Protestant son of the dream and its chronicler), "all changed, changed utterly."

Yeats goes on, in his famous poem about the 1916 Rising (a revolt against everything most of these houses stood for), "a terrible beauty is born." But here the beauty is not terrible. True, most of the houses were blown up. But late, and with odd courtesy. It is not Irish hatred that surprises the student of Irish history, but the lack of it. One wonders why it took them so long to get round to that destruction, when the houses were the symbol of so much.

The answer is in these photographs: it was going to happen anyway. Ireland was bound to absorb these anomalies into her earth and air, and here we can watch it happening.

Of course, some flickers of the old life remain; it was a process, not a catastrophe. But by an Irish irony it seems that many of the old houses that survive are inhabited by writers chronicling their demise: sometimes wildly, like J. P. Donleavy, or quietly, like David Thomson in *Woodbrook*, or best of all, because he deals with the waning life and the cracks in the walls before the final explosion, by J. G. Farrell in *Troubles*.

To such books and to many others, for the theme is inexhaustible, these photographs, chaste, almost abstract, etched and lacy as the skeleton of last year's leaf, are the perfect illustration. They also catch the process at what is perhaps its best moment. For some echoes of the old life still linger round the blank and staring windows, the jackdaw-blocked chimneys, echoes which a future generation may no longer be able to hear. Like the poet in the Anglo-Saxon "The Wanderer," who stood uncomprehendingly among Roman ruins, half-believing them to be the work of giants, they may stand among these and ask what race of men could have built them, and what for?

IN RUINS

The gates of Menlough, through which passed the guests riding to the receptions of Sir John Blake, M.P., the spendthrift. It is said that Sir John set forth from the small dock and remained adrift while furious creditors waited in vain on the lawns of the house. After his death his heirs remained, if in slightly reduced circumstances, until an accidental fire brought death to a daughter and finished their reign of eccentricity at Menlough forever.

Menlough Castle Gates.
Near Galway, County Galway.
Built in the 17th century. Burnt in 1910.

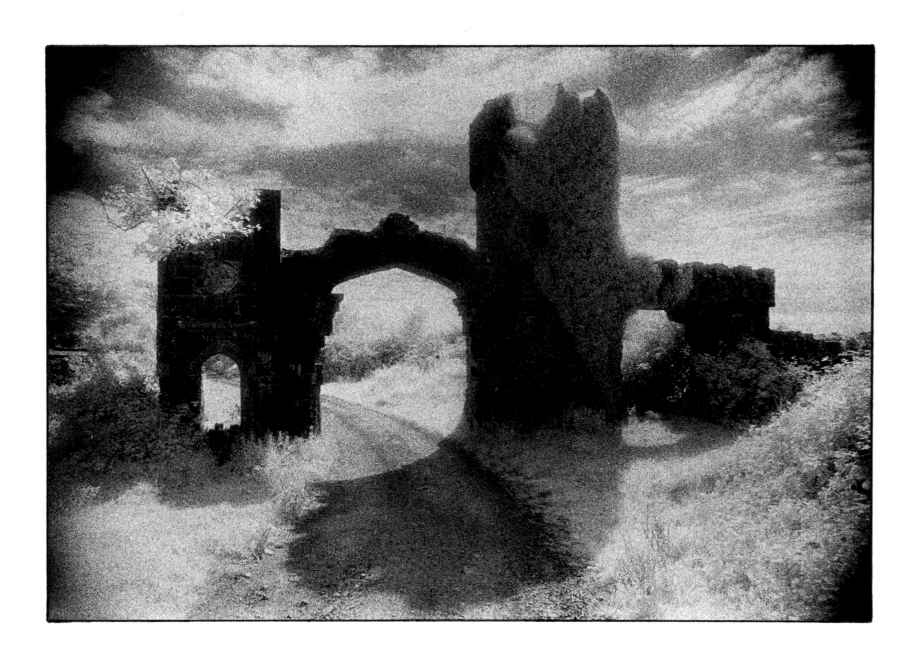

3

Finvarra, the king of the fairies of the West, keeps up friendly relations with most of the best families of Galway, especially the Kirwans of Castle Hackett, for Finvarra is a gentleman, every inch of him, and the Kirwans leave out each night for him kegs of the best Spanish wine. In return, it is said, the wine vaults of Castle Hackett are never empty, though the wine flows freely for all comers. (Adapted from *Ancient Legends, Mystic Charms and Superstitions of Ireland,* by the poetess "Speranza," the mother of Oscar Wilde.)

Old Castle Hackett. Near Headford, County Galway.
Built in the 13th century. Abandoned in 1705.

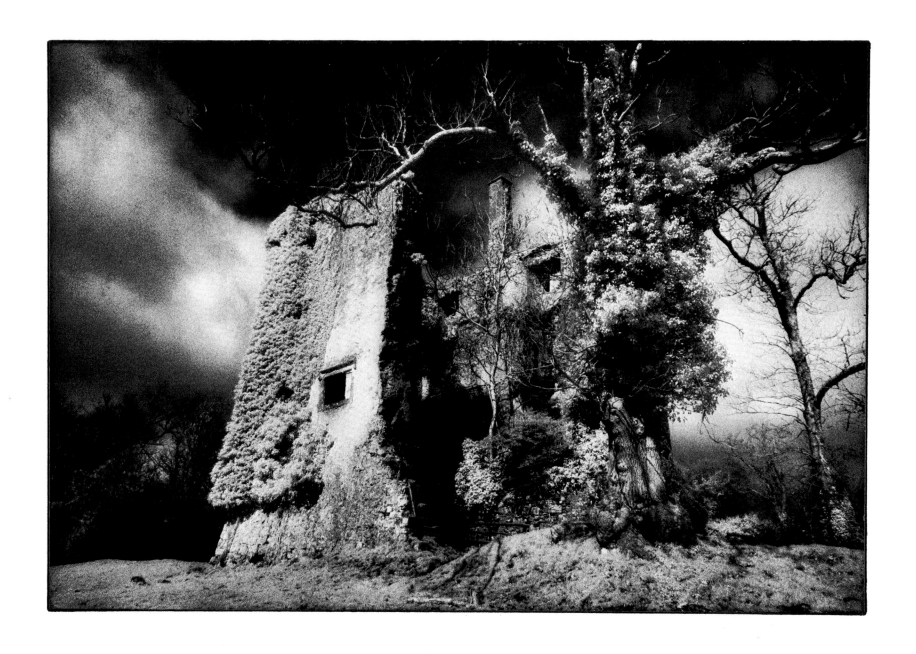

Tommy Martin was forced by the local military out of the already abandoned house that he was caretaking. He watched the fire engulf the house of the once powerful St. George family. This huge, gaunt ruin still remains.

Tyrone House. Clarinbridge, County Galway.
Built in 1779. Burnt in 1920 during the Troubles.

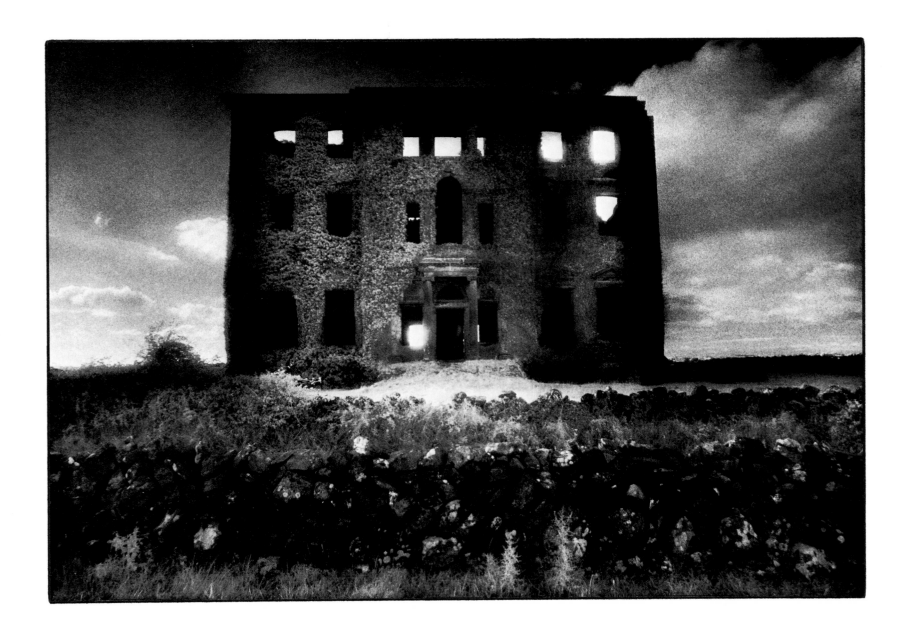

Richard de Burke, Fourth Earl of Clanricarde, built this modern castle for his intriguing wife, Frances Walsingham, who had first been married to the hero Sir Philip Sidney and then to the unfortunate Earl of Essex, favorite of Queen Elizabeth I.

The house was seldom lived in, and was accidentally destroyed by fire.

Portumna Castle. Portumna, County Galway.
Built in 1618. Burnt in 1826; presently
under restoration.

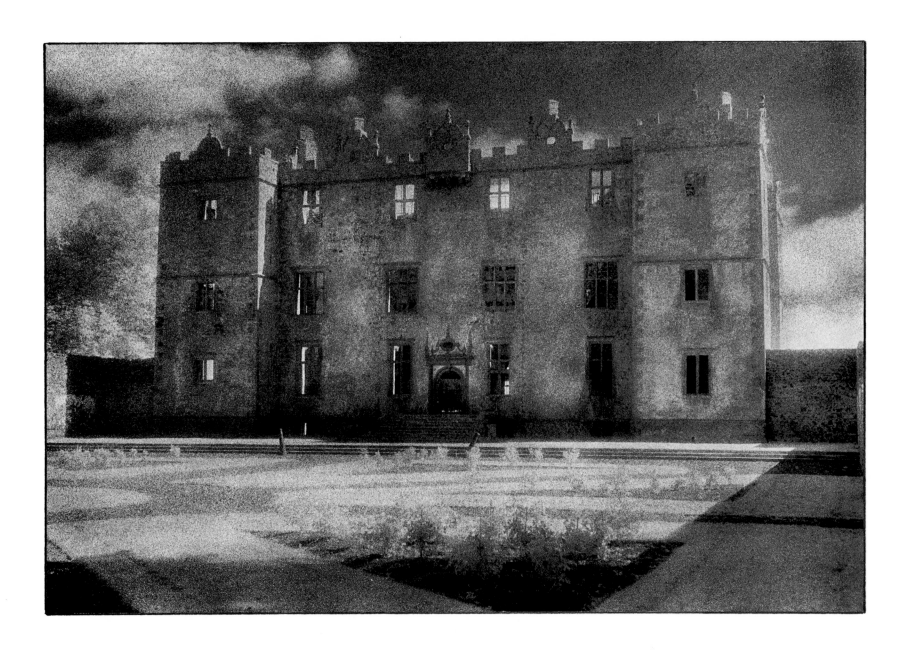

The great house of the Earls of Barrymore, from which they ruled 300,000 acres; the carelessness of a workman finished its life, and the Earl died only two years after the fire. His first son, known as "Hellgate," married the heiress of the tragic Ardo Castle. He ultimately ruined his rich and powerful family by his gambling.

Castle Lyons. Castlelyons, County Cork.
Built in the 16th century. Burnt in 1771.

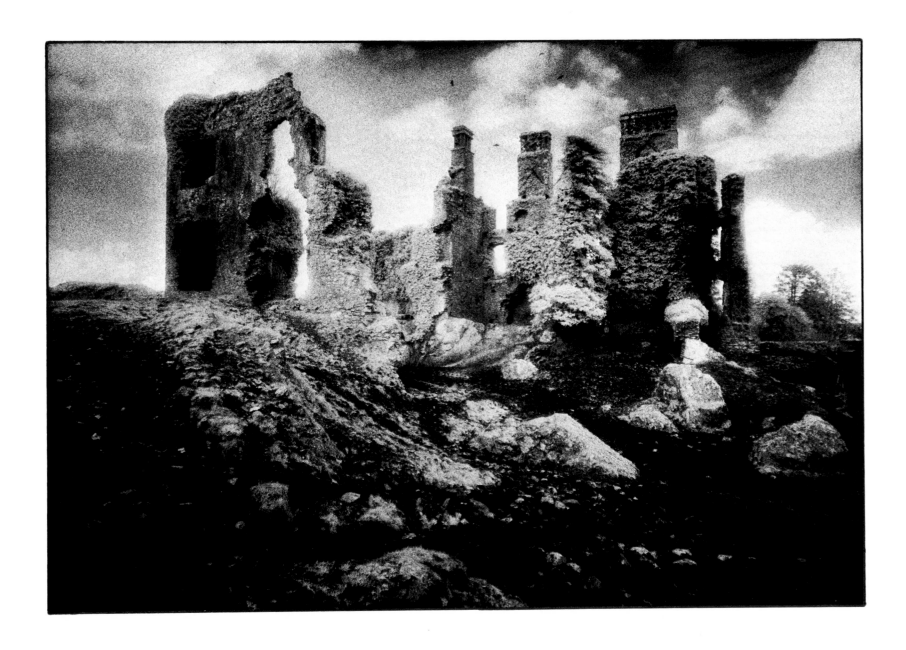

doric columns guard the entrance to the once fine house of the Lord Chancellor of Ireland, John Fitzgibbon, the Earl of Clare.

The drawing room no longer has silk on the walls or gilt furnishings; ivy hangs there now, and large brown cows move through the open walls.

Mount Shannon.
Near Castleconnell, County Limerick.
Built in the 18th century. Burnt in 1922.

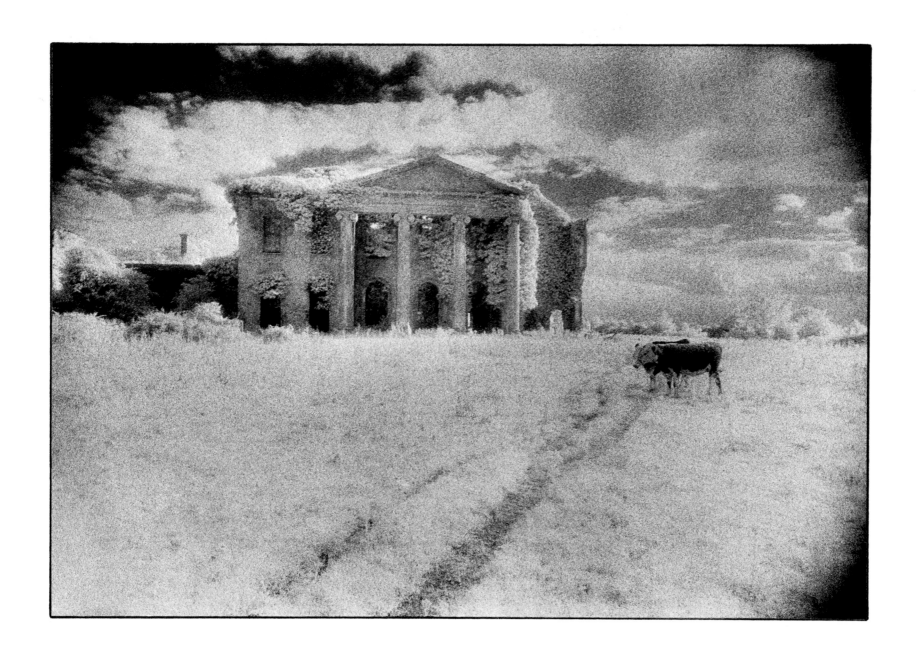

All that now remains is an ivy-clad brew-house, the petrified lake, and a souterrain of a once prosperous domain of the Lords de Freyne. Very faintly the red bricks, which formed the wings and arch away from the nonexistent central block, can be seen in the coarse grass. The man who tends this park of the past, and whose father served before him, said: "It was a beautiful house. I'm sorry you hadn't more to see."

Frenchpark House. Frenchpark, County Roscommon. Built in 1729. Demolished in 1953.

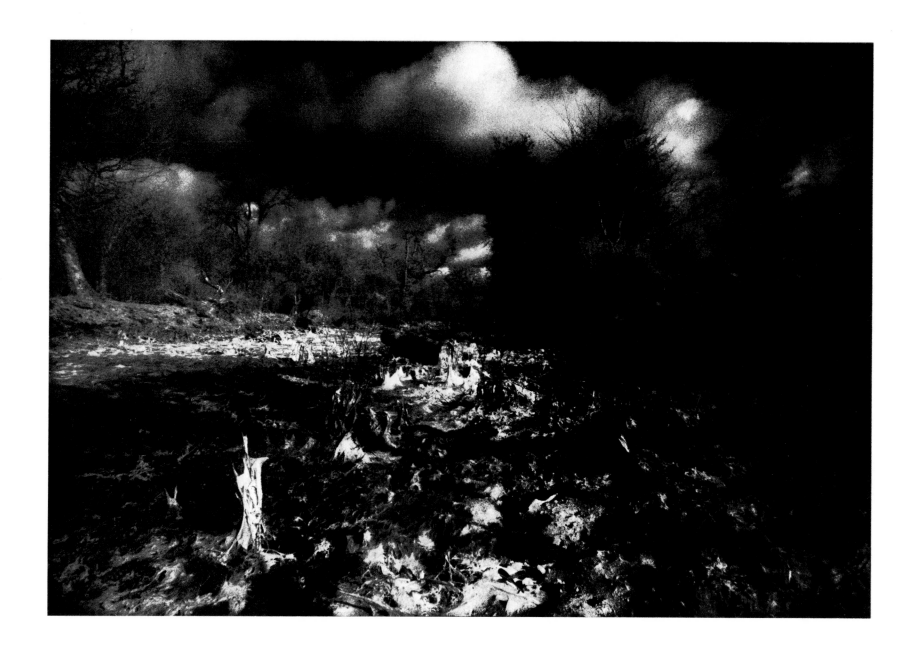

It is said that an old lady burnt to death in the main tower long before men set fire to Captain Alcock's castle. He died four years later, leaving four daughters to cope with the impossible.

It is the animals now who watch over the charred rooms of splendor and take shelter.

Wilton Castle. Near Enniscorthy, County Wexford.
Built in the 19th century.
Burnt in 1923 during the Troubles.

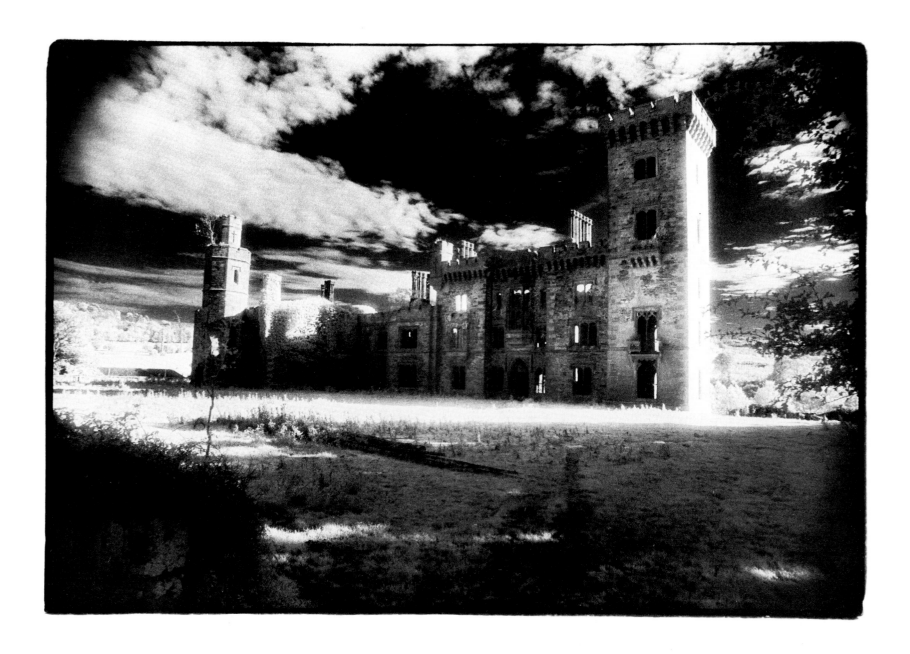

The stronghold of the great O'Briens, towering over the Shannon River, was fought over and finally destroyed by the armies of the conquering Cromwell. The silhouette of power and fortitude—and of Ireland.

Carriogunell Castle.
Near Clarina, County Limerick.
Built in the 15th century. Blown up in 1691.

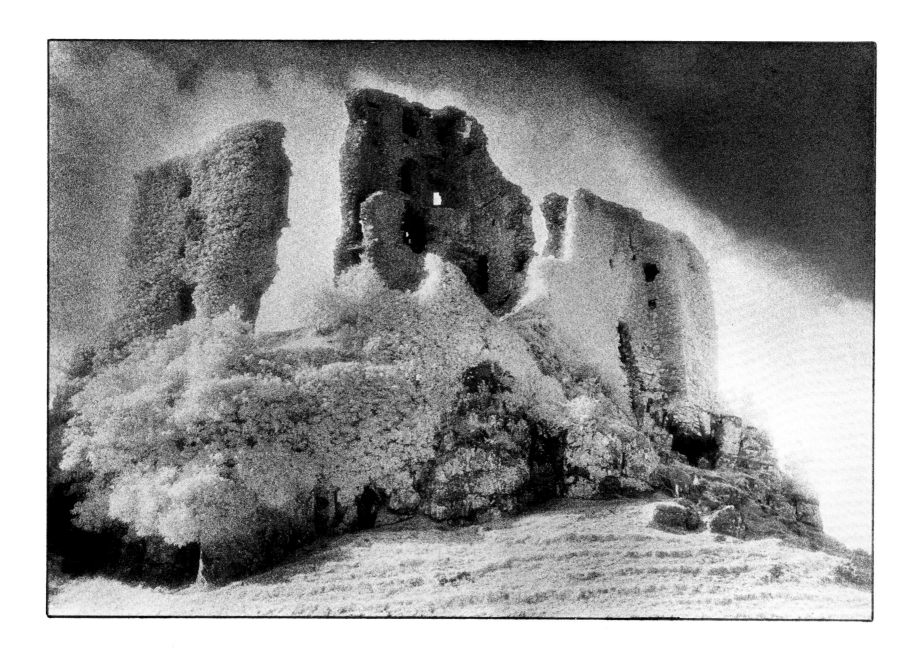

Castlestrange, burnt down by mistake at the end of the Great War, was owned by a lady called Michael. It is said by the locals that the owner was half man and half woman.

Former seat of the L'Estrange family, Castlestrange. Near Athleague, County Roscommon. Built in the 16th century. Accidentally burnt down in 1918.

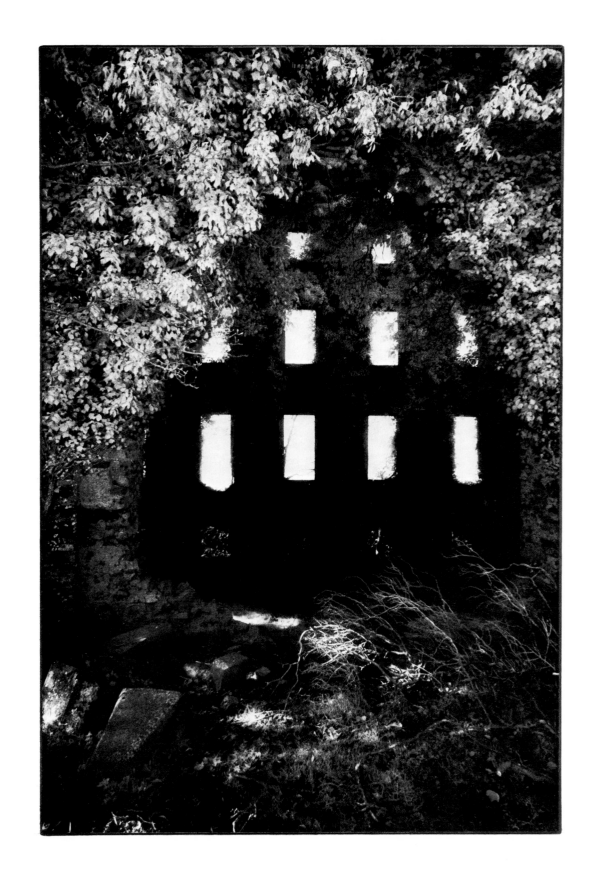

m̲r. Edward William Godwin built his castle of correctness for the Earls of Limerick. In the end his plans were thwarted not by the lack of money or the forces of evil but by damp. It was sold and resold, and finally stripped of all the new ideas of poor Mr. Godwin.

Dromore Castle. Pallaskenry, County Limerick. Built in 1867–70. Abandoned in the 1920s during the Troubles.

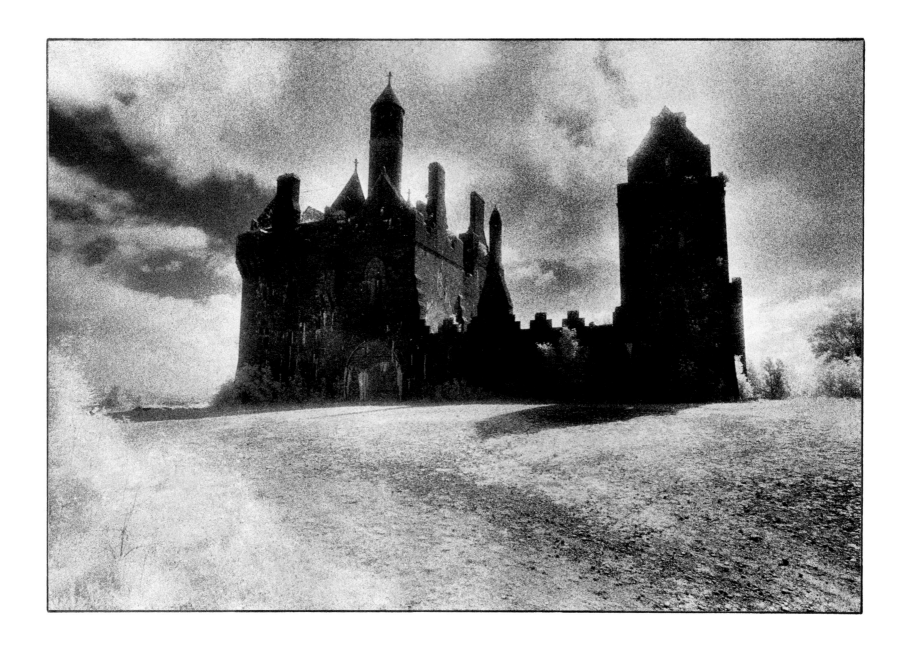

Pennants cease to fly from the lofty pinnacles of Mr. Matthews's castle. Just the crows circle and inquire if all is well in their Gothic Revival folly of finer days. Now through the halls the sheep of Golden keep company with the memories of the Dukes of Ormond, the Earls of Llandaff, Sir Richard Morrison, Viscount de Rohan Chabot, and the Daly family, who remember what it was to dine at the great house of the Matthewses at Golden.

Thomastown Castle. Near Golden, County Tipperary. Built in 1670. Fell into disrepair after 1872.

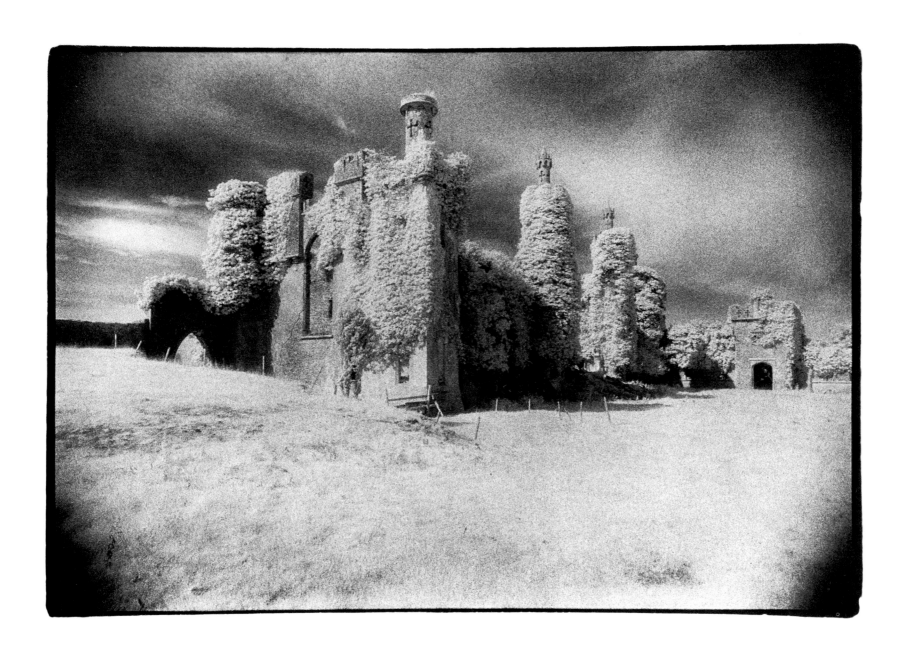

In the gardens are a number of trees which have been planted by distinguished visitors, amongst whom were the late Duke of Clarence, the present Prince of Wales, . . . the Count of Turin, the Earl of Halsbury and the late Sir H. M. Stanley." (Extract from C. L. Adams, *Castles of Ireland*, London, 1904, pp. 102–3.)

Castleboro House.
Near Enniscorthy, County Wexford.
Built in 1840. Burnt in 1923 during the Troubles.

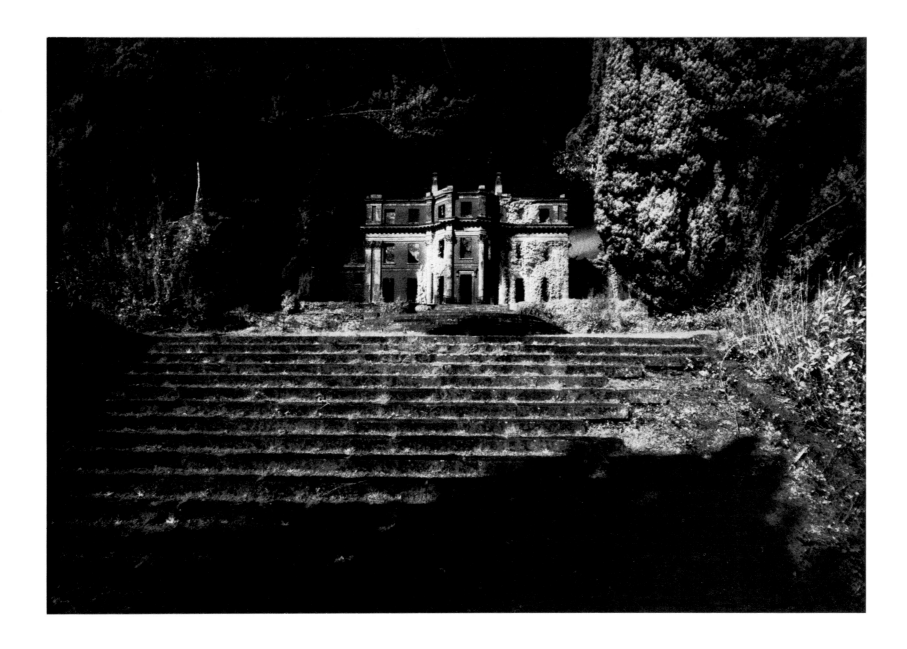

An obelisk marks the alleged planting of Ireland's first potato by Sir Walter Raleigh. No one remembers Lawrence of Arabia—the Chapmans' illegitimate son, owners of Killua's lost towers—or the Chapmans' rooms from which the lakes can be seen and the follies of their imaginations can be felt.

Killua Castle. Clonmellon, County Westmeath.
Built in 1780. Abandoned in the 1930s.

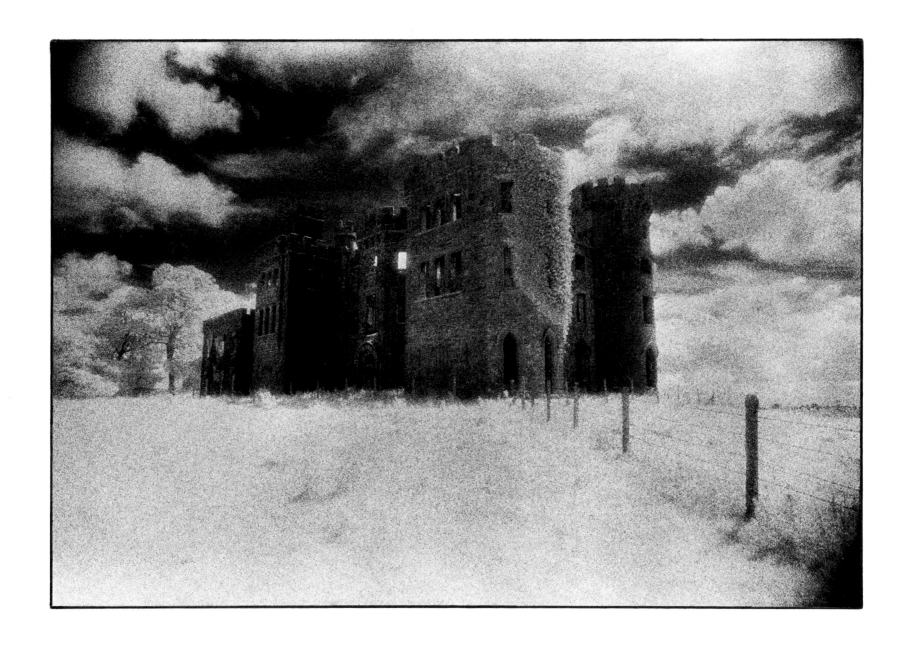

Geoffrey de Maurisco built this huge monastery for his Augustinian monks. Cromwell destroyed his work, leaving only the walls of ideas as our heritage.

Kells-in-Ossory. Callan, County Kilkenny.
Founded in 1193. Confiscated and dissolved in 1653.

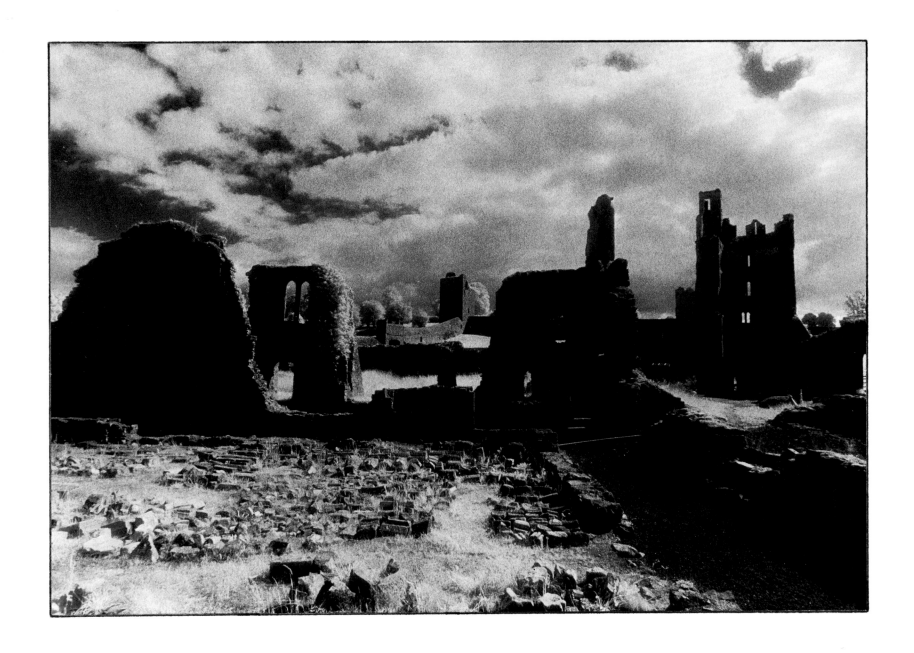

Penelope Smyth left this enchantment for the love of Prince Capua, brother of King Ferdinand II of the Sicilies. During the troubled times, her great niece held the house in safety while her husband took his hounds for sport in England.

Ballynatray House.
Near Glendine, County Waterford.
Built in 1795–97. Presently under restoration.

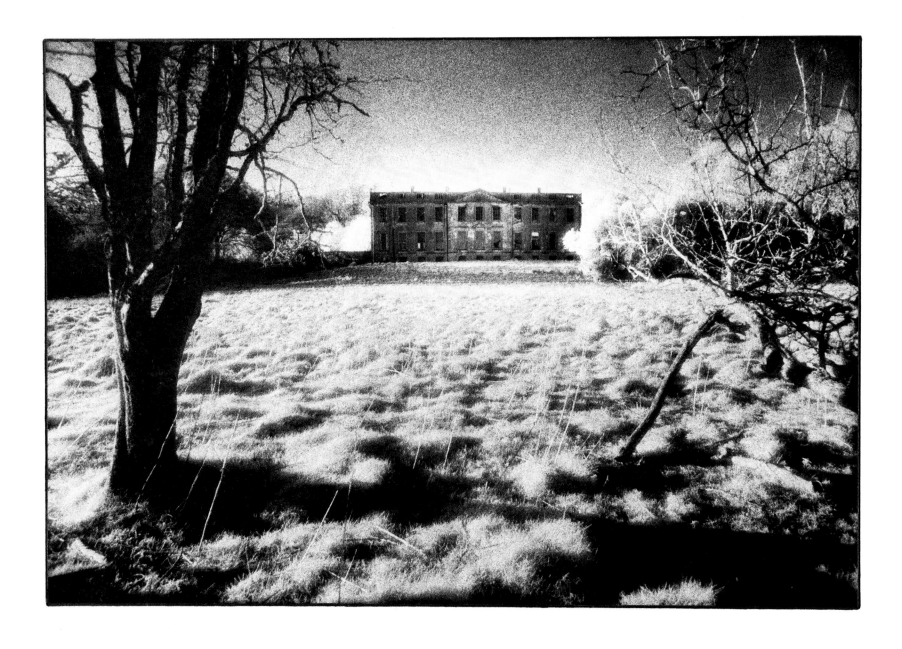

The young heir Costen, tricked by his guardian, was pursued by His Majesty's troops along the cliffs. His horse fell and he was hanged by the reins. The stone arch on Ardo's desolate domain is called "The Gallows of the Heir."

Tragedy through the Prendergasts, Barrymores, Goghlans; fame through the Dukes of Castries, McMahon, the Marshal of France; and the divisions of hatred, which brought about the family McKenna's financial ruin—all have added their story to Ardo's thin wall.

Ardoginna House. Ardmore, County Waterford.
Built in the 18th century. Abandoned in 1918.

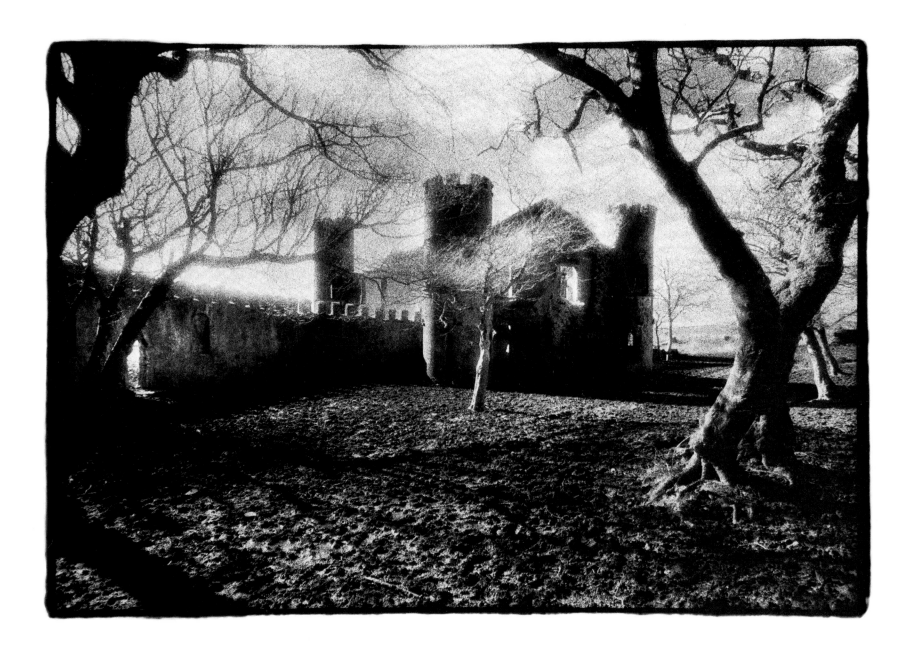

W here is Kenure Park?" I asked the post-mistress of the village. "It's been pulled down," came the quick reply. She was wrong, but only by a matter of weeks; the bulldozer, rather than hostile folk, erased forever the grand Palmer mansion.

 Built for the Second Duke of Ormonde, Viceroy of Ireland.

Kenure Park. Rush, County Dublin.
Built in 1703. Demolished in 1978 to make way
for the construction of council houses.

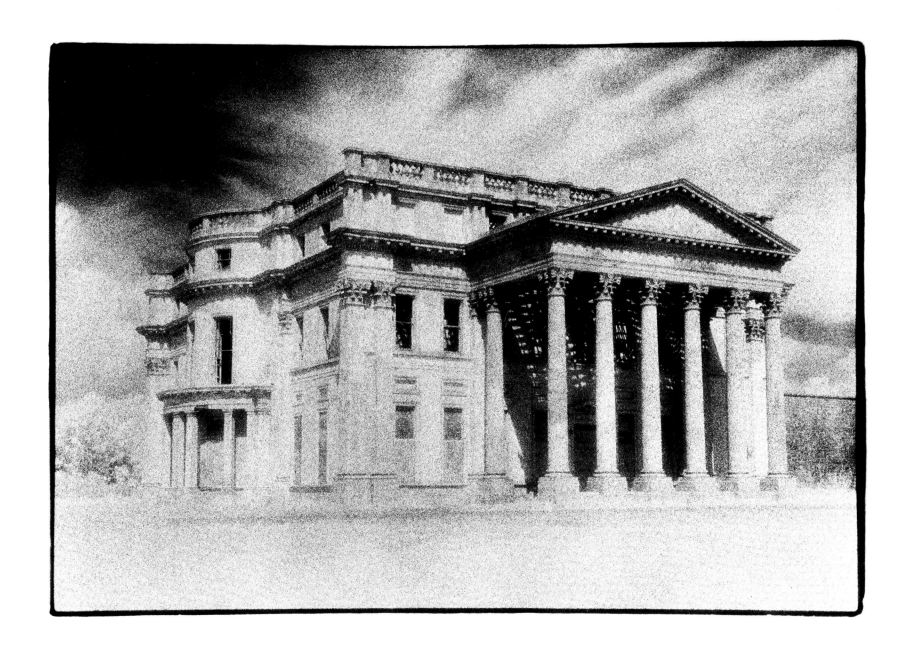

oydrum, the Gothic Revival mansion of
Lord Castlemaine.

Moydrum Castle. Near Athlone, County Westmeath.
Built in 1812. Burnt in 1921 during the Troubles.

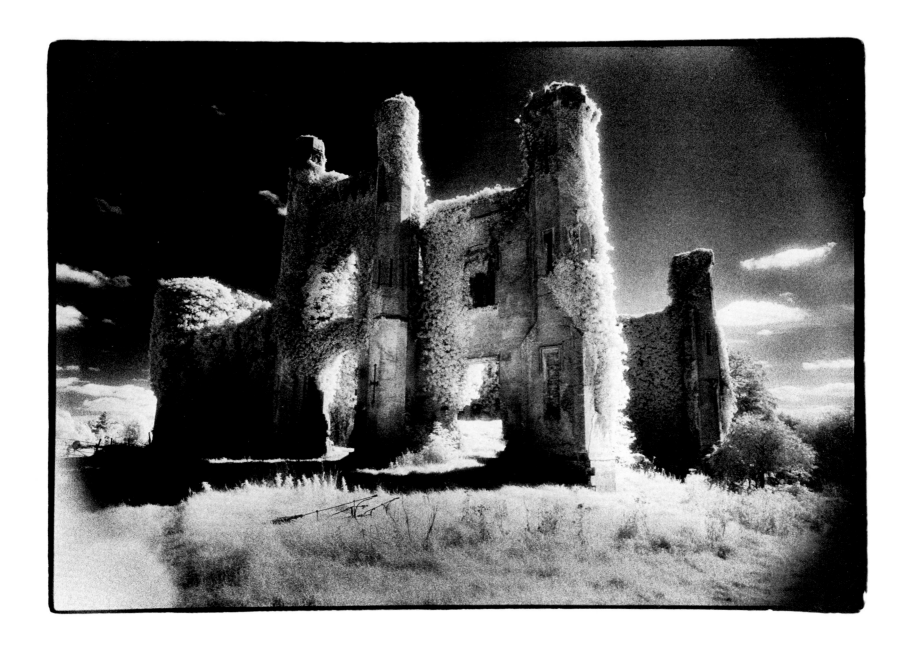

The once fine home of the Tighe family. Their daughter Lady Louisa danced at the ball in Brussels before Waterloo. With her own hands she buckled the sword onto Ireland's greatest soldier, the Iron Duke of Wellington.

Woodstock House. Inistioge, County Kilkenny.
Built in 1740. Burnt in 1922 during the Troubles.

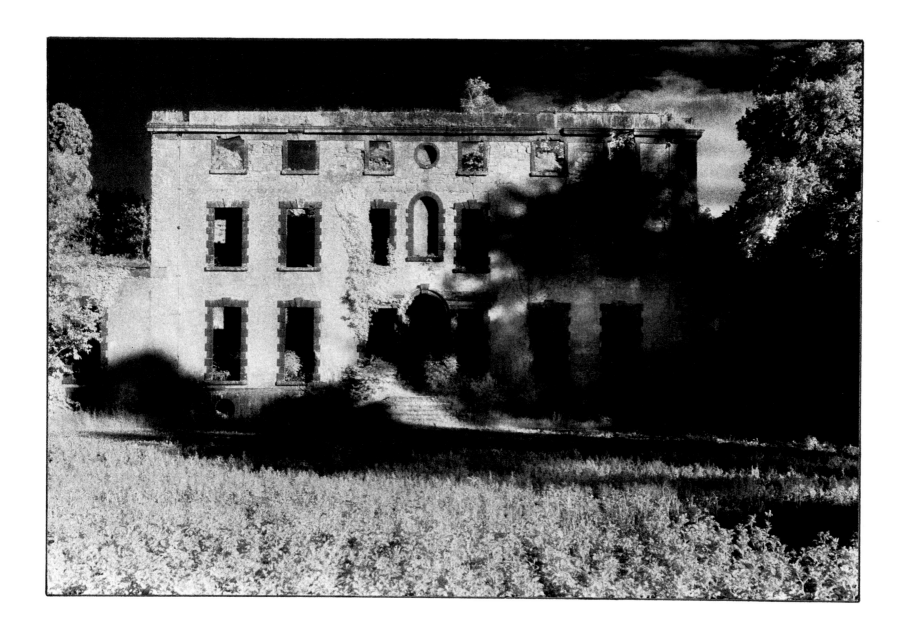

The beautiful home of the powerful and prolific Croker family. The priest said to Captain Edward Croker on his deathbed, "Ah! Sir, it is a far, far better place that you go to now." Captain Croker, sitting up in bed, surveyed his wondrous domain through the window, replied, "I doubt it," and fell back dead.

Ballynaguarde House.
Near Ballyneety, County Limerick.
Built in 1774. Fell into disrepair in this century.

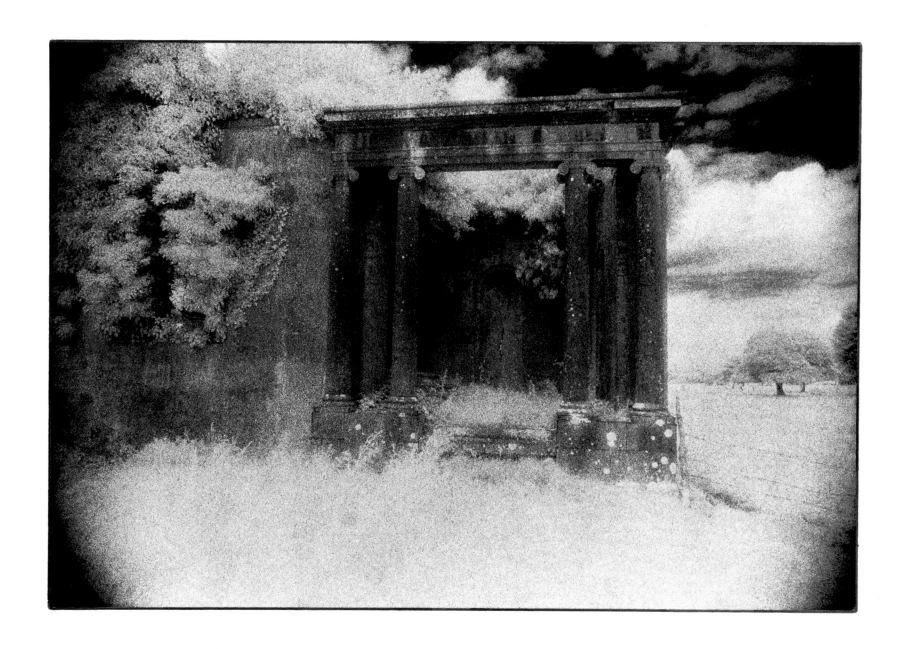

The Gothic-towered fantasy of the Duckett family; at one time their estates covered 5,000 acres. The immediate gardens were over 7 acres, tended at the height of their enchantment by more than fifty gardeners, who were each paid not more than nine shillings per week.

Mrs. William Duckett lived on in the great mansion for years after her husband's death in 1908. After her came the sale in 1930, and in 1933 the house mysteriously burnt.

Duckett's Grove. Carlow, County Carlow.
Built in 1830. Burnt in 1933.

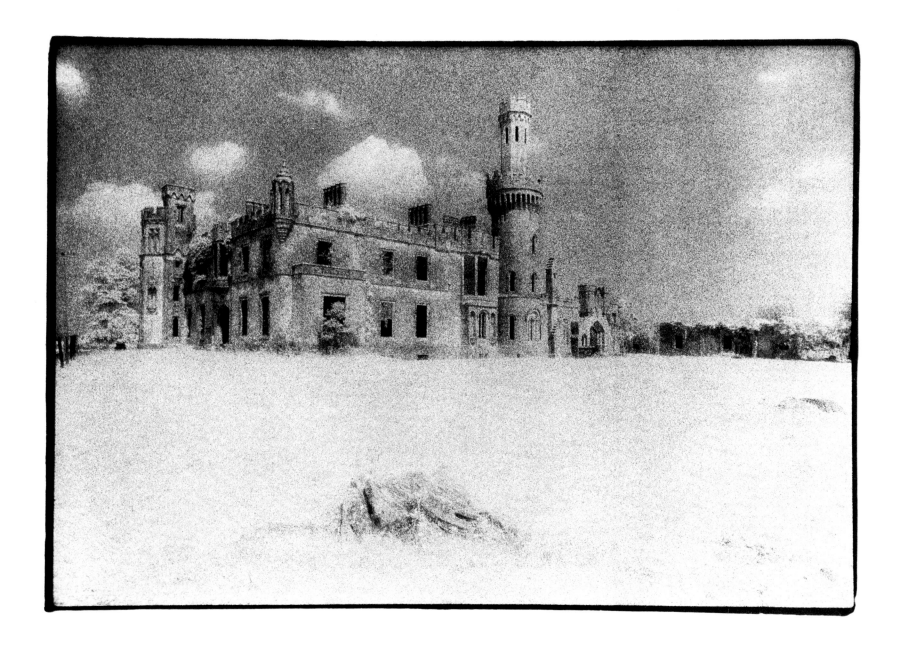

The gates to the stables at the home of the Lord of St. Leger. The first steeplechase ever was started here in 1752 and was raced from the church in Doneraile to the steeple church of Doneraile, and this is where a traveling poet lost his gold watch, cursed the family in verse for his misfortune, but rewrote his poem when the Lady St. Leger replaced his timepiece.

Doneraile Court. Doneraile, County Cork.
Built in 1725. Now under restoration by the Irish Georgian Society.

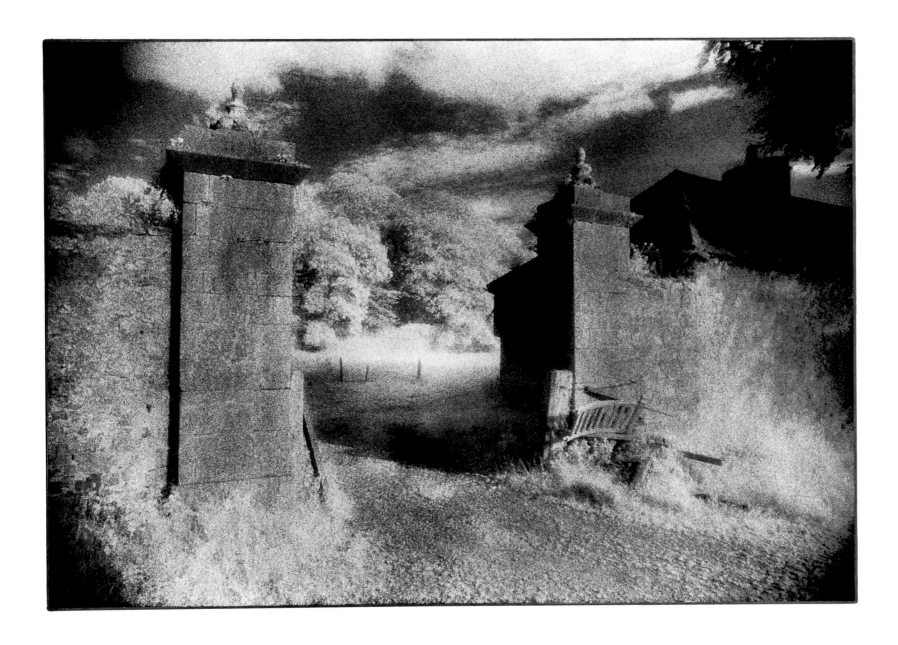

during the Troubles, superstitions of fate were heard and believed. Guests were awakened by the rattling of chains in the night (Dunboy Castle was the inspiration for Daphne Du Maurier's novel *Hungry Hill*), but it was only the death throes of a cock killed the previous evening. The Puxley family left, and, while away, the Free Army of Ireland stole across the lake to burn the palace of Copper John, whose vast Cornish fortune had gone into building this wonder of the Victorian Age. The Civil War ended two days after Dunboy was put to the torch.

Dunboy Castle.
Near Castletownberehaven, County Cork.
Built in 1866. Burnt in 1921 during the Troubles.

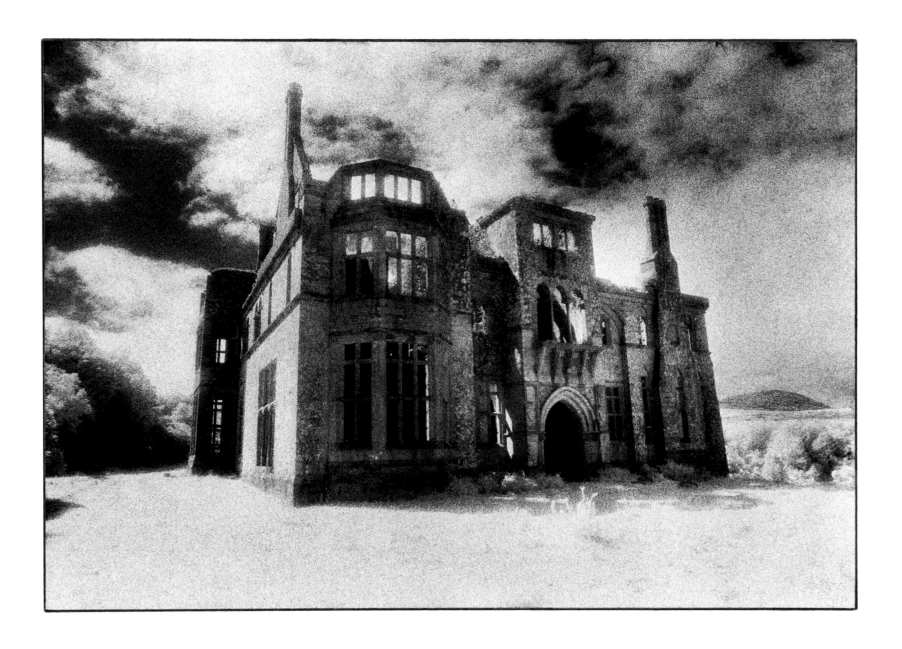

They brought the workmen from Italy to complete
the magic for Copper John's marble halls.

The Great Hall, Dunboy Castle.
Near Castletownberehaven, County Cork.
Built in 1866. Burnt in 1921 during the Troubles.

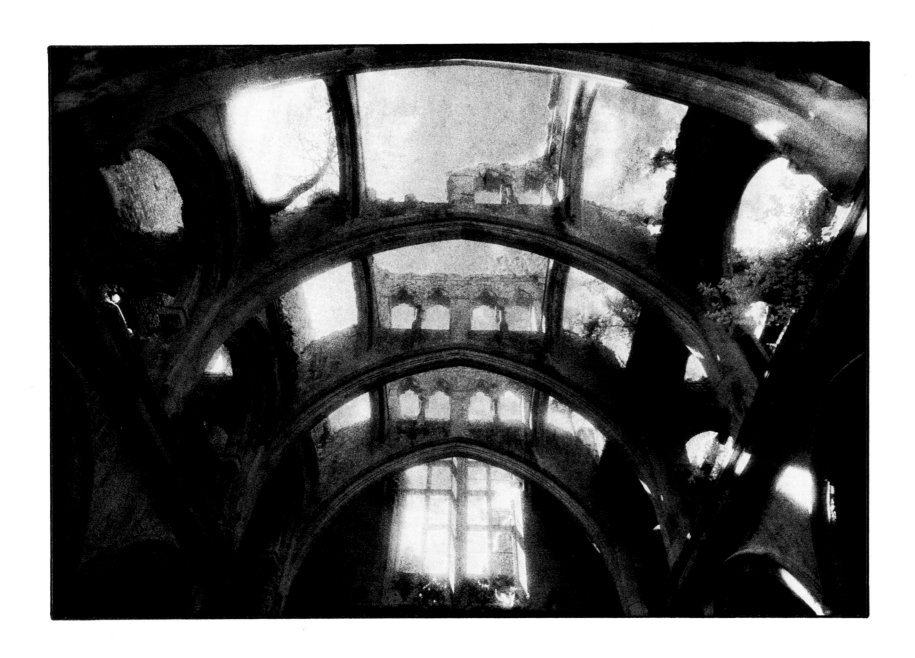

Known as the "ill-fated tower of Mahon Macchūin," from where Cromwell's murderous troops spent time to eat and drink before the night sacking of Quin Abbey.

A woman was sent from this tower to warn Commander Hugh O'Neill during the siege of Limerick. She died in the beleaguered city.

Danganbrack Tower. Near Quin, County Clare.
Built in the 13th century.
Destroyed in 1640 by Cromwell's troops.

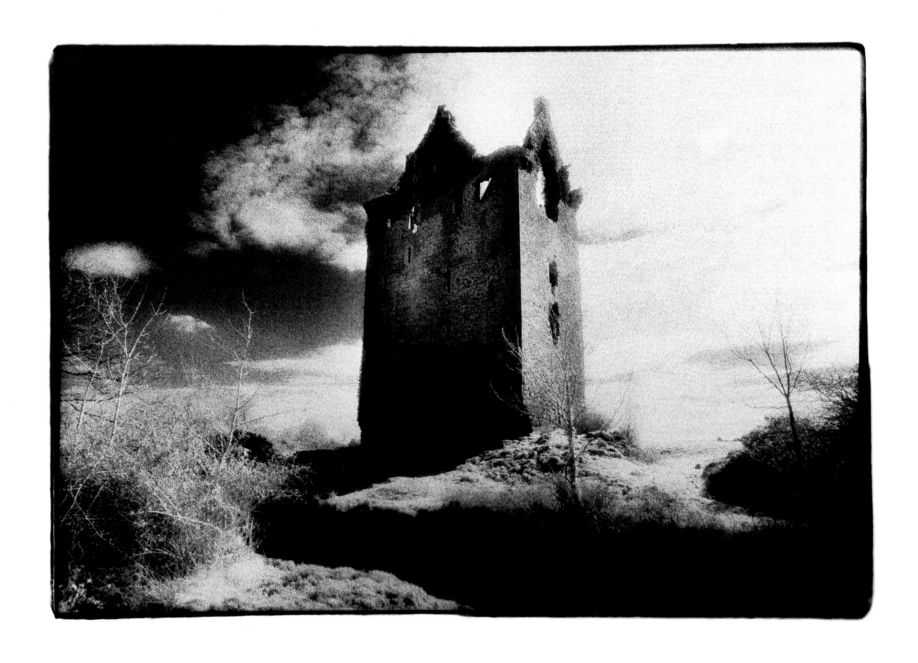

It is said that there were many skulls found in the lake after rumors of killings had circulated for years. Blindness, drink, and poverty forced the last of the Harris-Temple family to abandon their heritage in 1921.

Waterston House.
Near Athlone, County Westmeath.
Built in 1749. Abandoned in 1921 and sold to the
land commissioner by the agent.

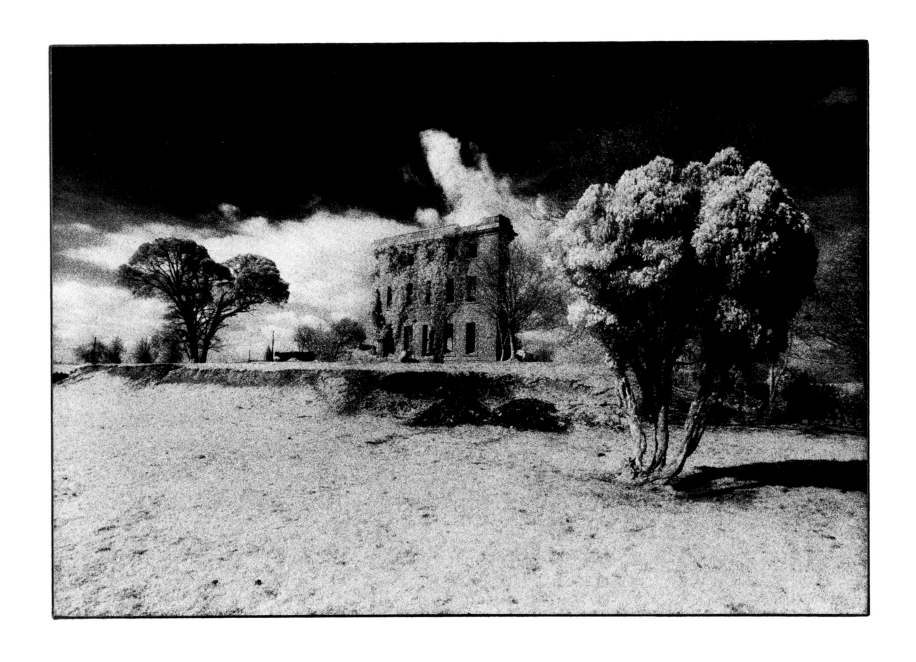

Ransacked during the Troubles, the people of Galway town carried off the house contents until very little remained. Some silver was later found in the wood, and the grand piano was retrieved from the barber's shop and brought home. Family papers were rescued, including a receipt dated 1068 for one cow. Then the second Lady Wallscourt gambled away all that remained, until in desperation she sold the roof of lead to pay for Monte Carlo. Finally, while visiting her lawyer, she died trying to raise yet more money with which to turn the dice.

Ardfry House. Near Oranmore, County Galway.
Built in 1770. Dismantled in the 1930s.

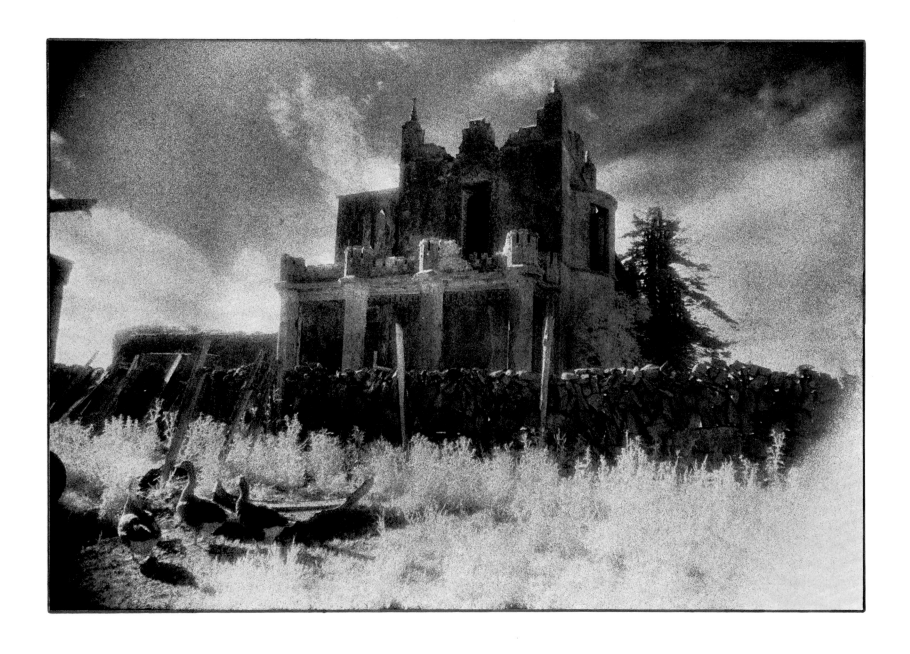

Arch Hall is now a haunted shell of the Gachet family. An arch stands by Chilean pines that were planted to celebrate the birth of twin boys. One tree lives in memory of a life given during World War I. The other is dying, for the second twin attacked an old lady; she cursed him and foretold that his pine would wither and die. It is said that the boys' father, after returning to the Hall, went blind and died for having stolen the eye of a god from an Indian roadside shrine.

Arch Hall. Near Wilkinstown, County Meath.
Built in the 18th century.
Burnt in 1922 during the Troubles.

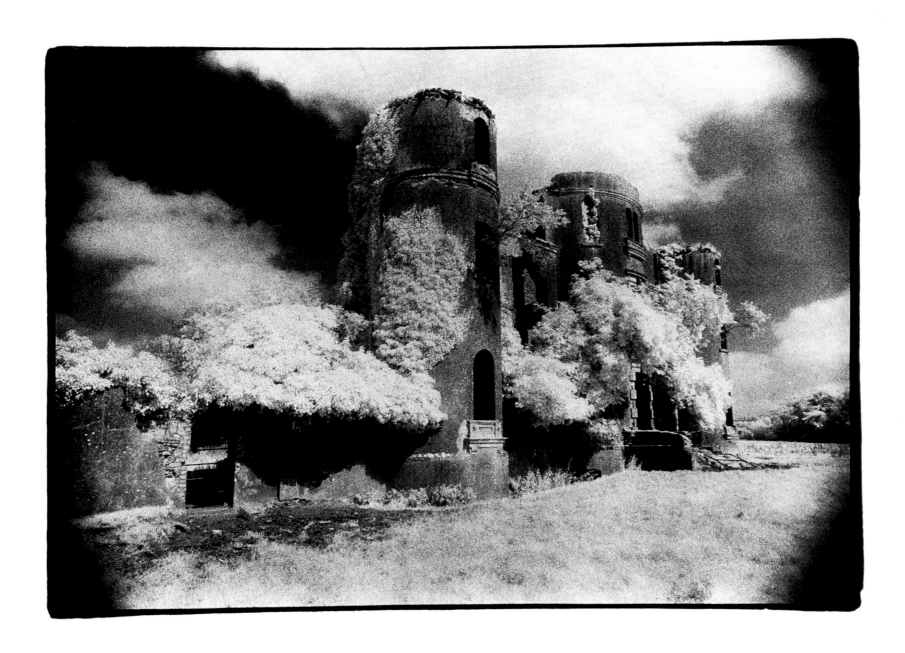

The Belview Eyecatcher, built by the Lawrences of Lancashire who came to Ireland in 1571. Nothing remains of the house, just an arch built in memory of the Irish Volunteers—who either volunteered or were shot—and this folly, standing alone in the ravaged parkland.

Belview House. Lawrencetown, County Galway.
Built in the 19th century.
Burnt in 1922 during the Troubles.

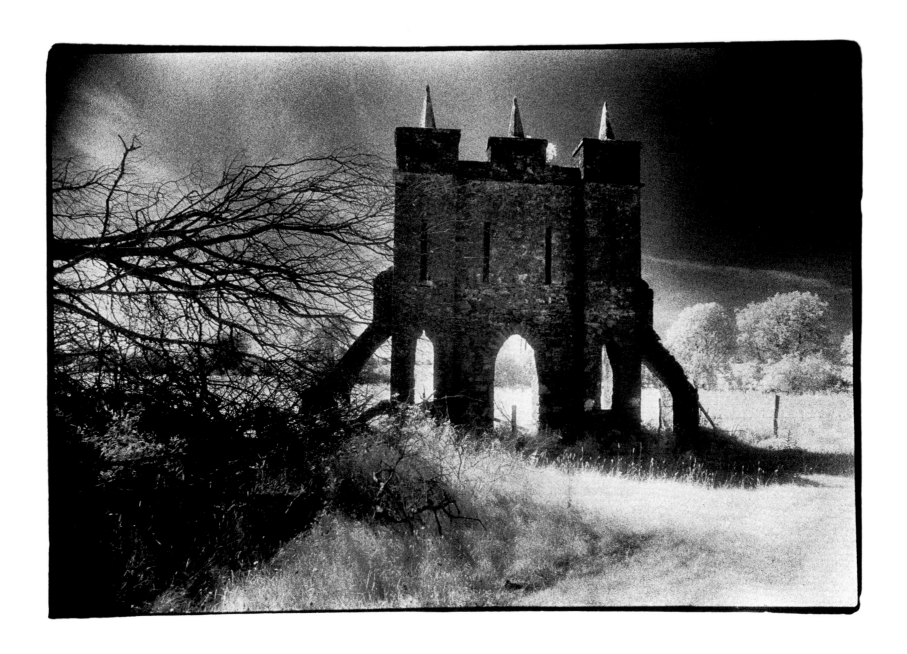

There was a ball given in the newly restored house for the tenth Lord Carberry's coming of age. A year later, he went to war to become an ace flyer in His Majesty's Royal Flying Corps. He returned to a vanished world where only a few could survive playing at castles.

Castle Freke. Near Rosscarberry, County Cork. Built in 1720. Abandoned in the 1920s and dismantled in 1953.

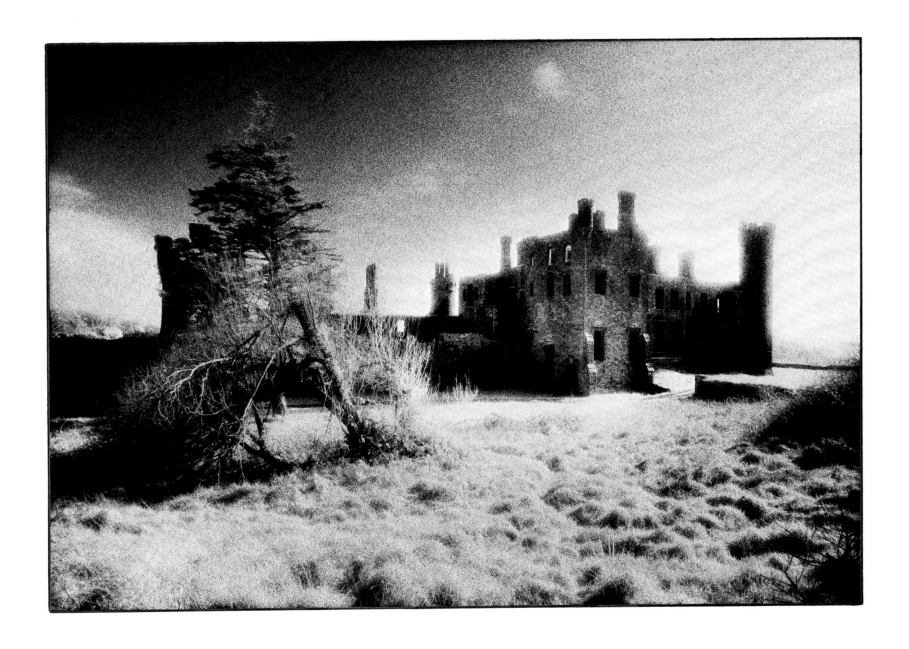

down these stairs came the Countess of Bandon
to join her house party for dinner.

Castle Bernard. Near Bandon, County Cork.
Originally built in the 16th century. Remodeled in 1815.
Burnt in 1921 during the Troubles.

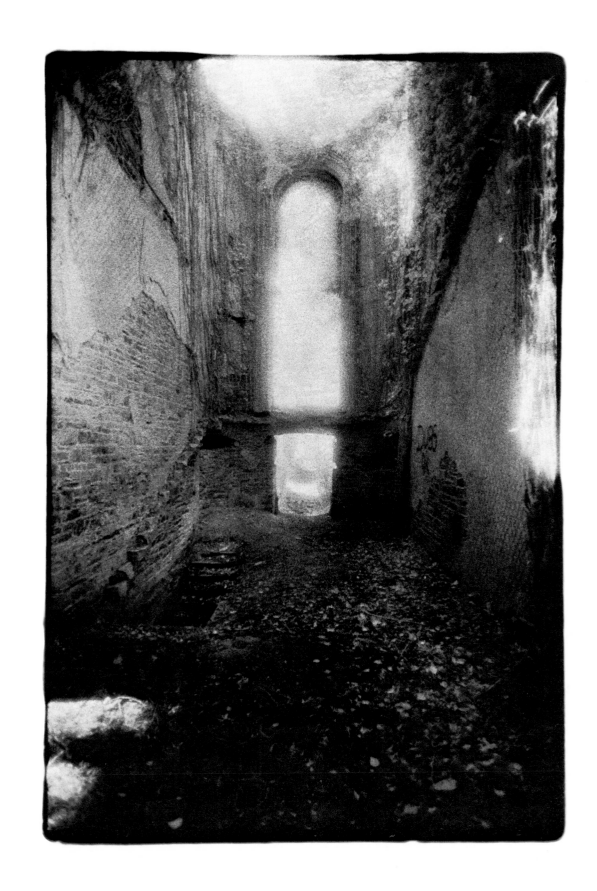

Major Henry Langley thought to build in the manner of the Middle Ages a castle, moat, and gatehouse. But only the great gate tower was ever completed, for he was killed by a piece of falling masonry from his own creation.

Brittas Castle. Near Thurles, County Tipperary.
Building begun in 1883. Unfinished.

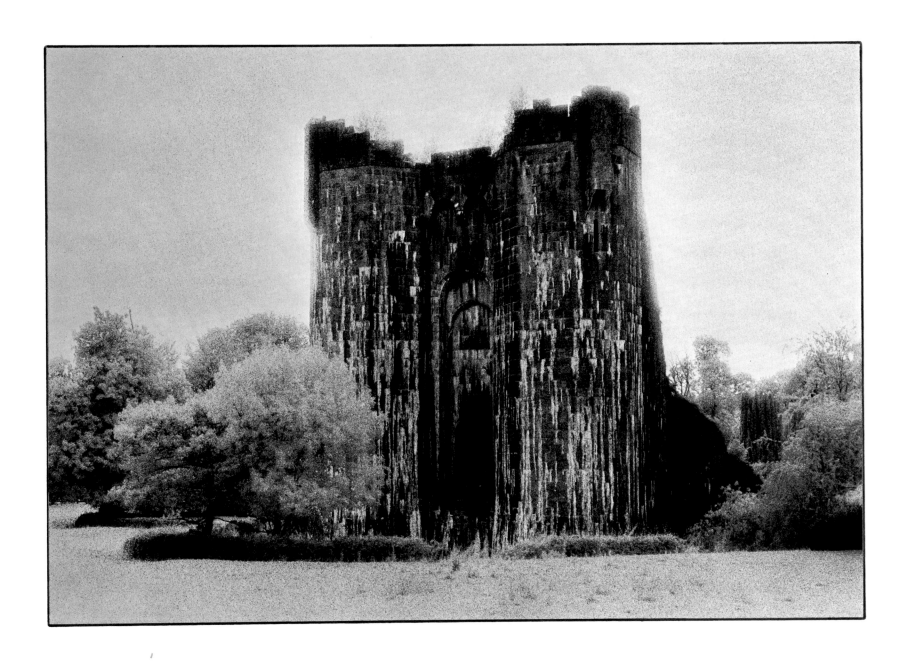

The summer house of the great Carew family. It was used only for a few weeks in any one year.

Castleboro House.
Near Enniscorthy, County Wexford.
Built in 1840. Burnt in 1923 during the Troubles.

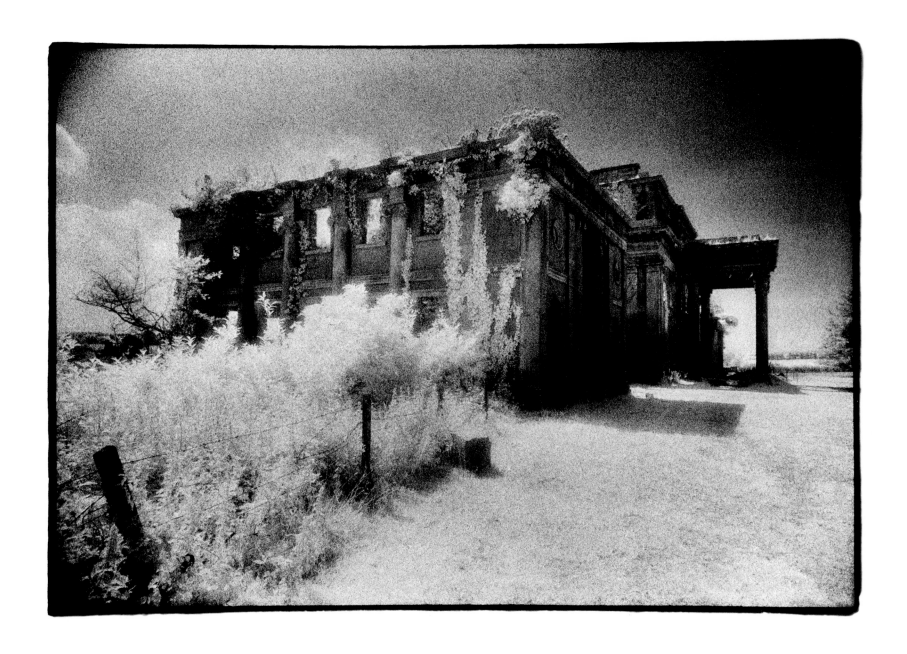

Before leaving to settle a dispute with his neighbors, Sir Walter Coppinger instructed his servants that if he did not return by a certain time from this fateful meeting, they were to set fire to his house. Sir Walter won his wager but forgot his instructions. He arrived late, and found his house a charred shell.

It is said that Coppinger's Court had golden gates that were thrown into the nearby Lake Vickreen, and that the sunlight's fall marks the location of Sir Walter's buried crocks of gold for the traveler who is able to see through three of the mansion's windows at one time.

Coppinger's Court. Near Rosscarberry, County Cork. Built in 1618. Burnt in 1641.

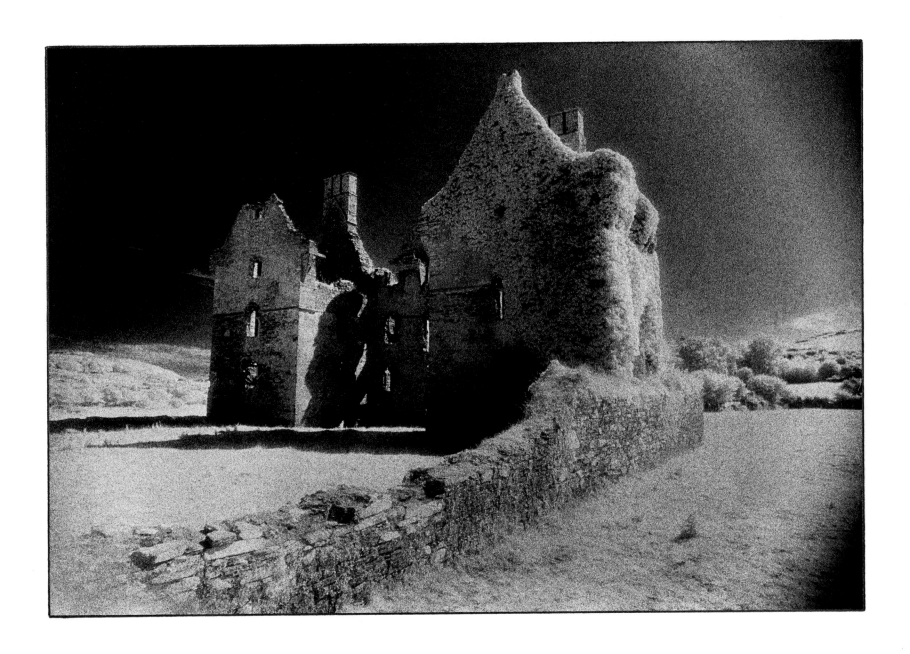

Arches of light lead to the view of the greatest Palladian house in Ireland. This folly was built in memory of Speaker Connolly by his widow.

Connolly's Folly. Near Celbridge, County Kildare. Built in 1740 by his widow.

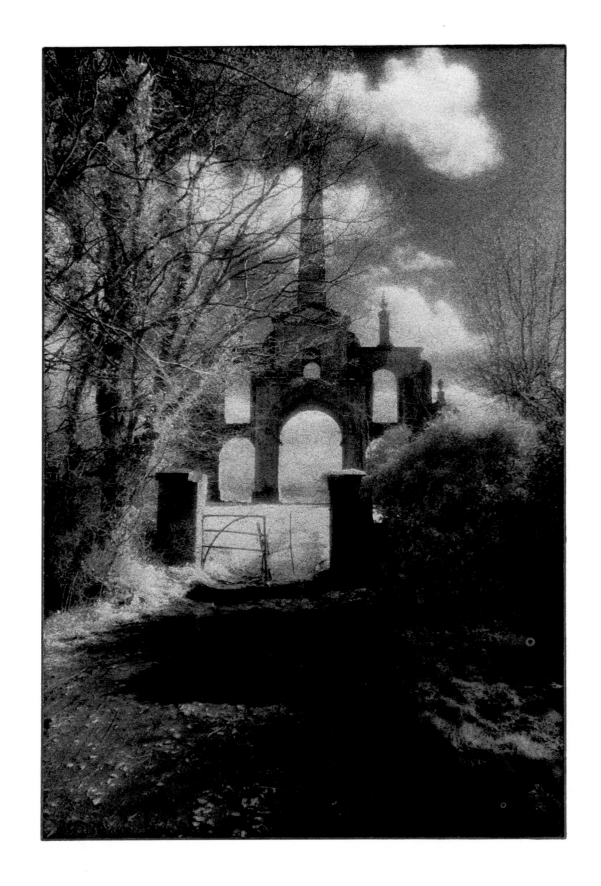

during dinner the Countess of Bandon and her husband were surprised by intruders, and with their guests were ordered out of the house while it was put to the torch by the local military.

As she watched her castle disappear in a sea of flames, her only defense was to sing "God Save the King."

She sang standing erect, and she sang for a long time.

Castle Bernard. Near Bandon, County Cork.
Originally built in the 16th century. Remodeled in 1815.
Burnt in 1921 during the Troubles.

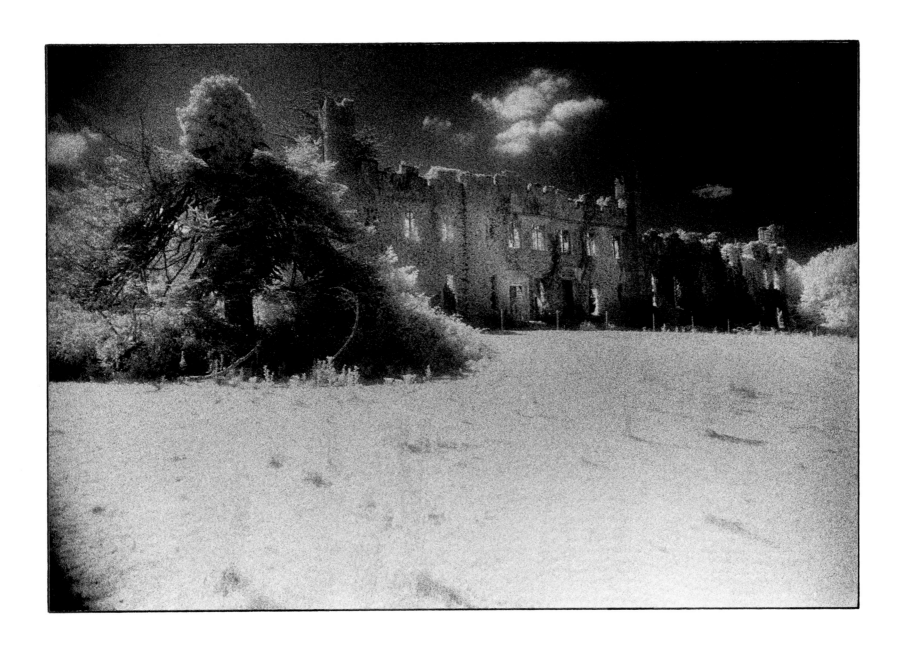

The grand Triumphal Arch of Rosmead, called "Smiling Bess," was said to have been brought from Italy. It was moved from Glananea nearby, and it remains the silent entry to a forgotten Park of Memories.

Rosmead House. Near Delvin, County Westmeath. Built in the 17th century. Burnt in 1923.

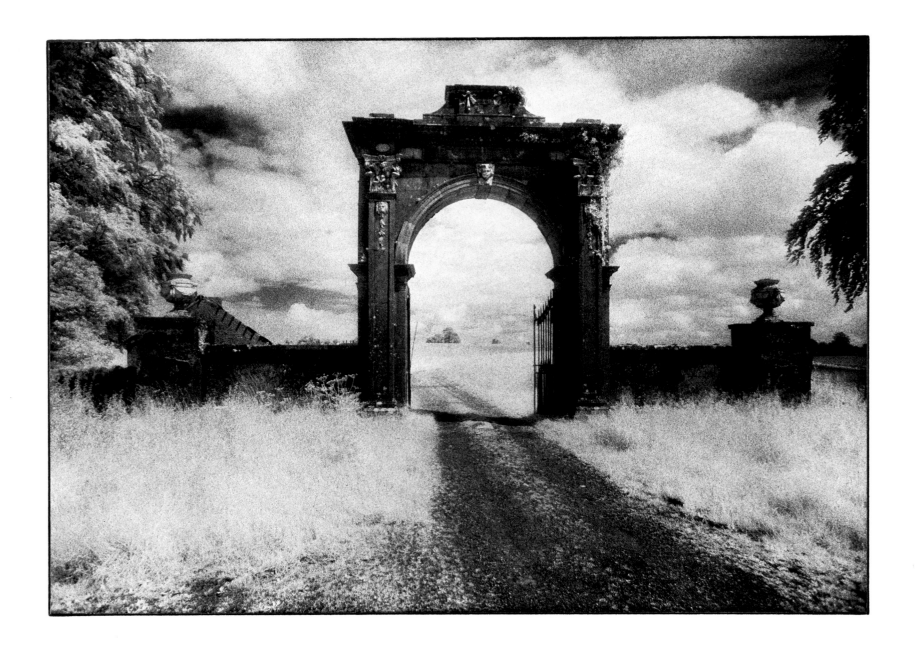

Every Friday fifty horses were shod in preparation for Mr. Bruen, who seldom if ever came. The estate was run in the absence of Mr. Bruen by the much-hated agent, Mr. Routledge, who paid the rents of the Protestant tenants rather than let any land fall into the hands of the Catholics. If, on the other hand, the Catholics could not pay, the land was given to the Protestants.

It took twenty-five years to build the house.

Coolbawn House.
Near Enniscorthy, County Wexford.
Built in 1840. Burnt in 1914 during the Troubles.

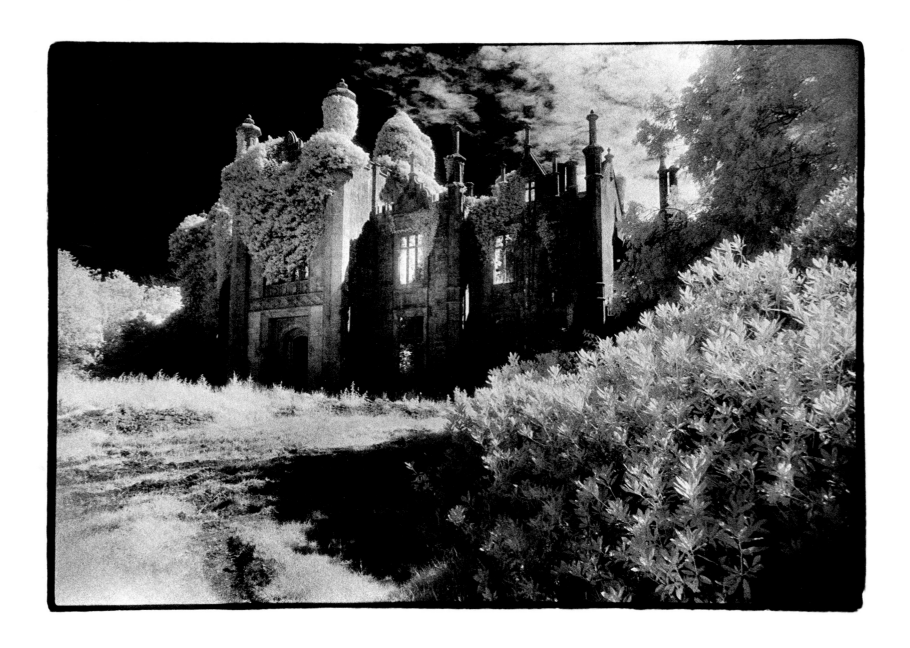

Built by the warlike O'Carrolls. Tragic and haunted, this castle was beset with the killings of brother against brother, and, it is said, is still inhabited by the ghost of an evil-smelling half human/half beast who lives on the tower stair overlooking the hangman's field.

Leap Castle. Near Birr, County Offaly.
Built in the 14th century.
Ransacked and burnt in 1922.

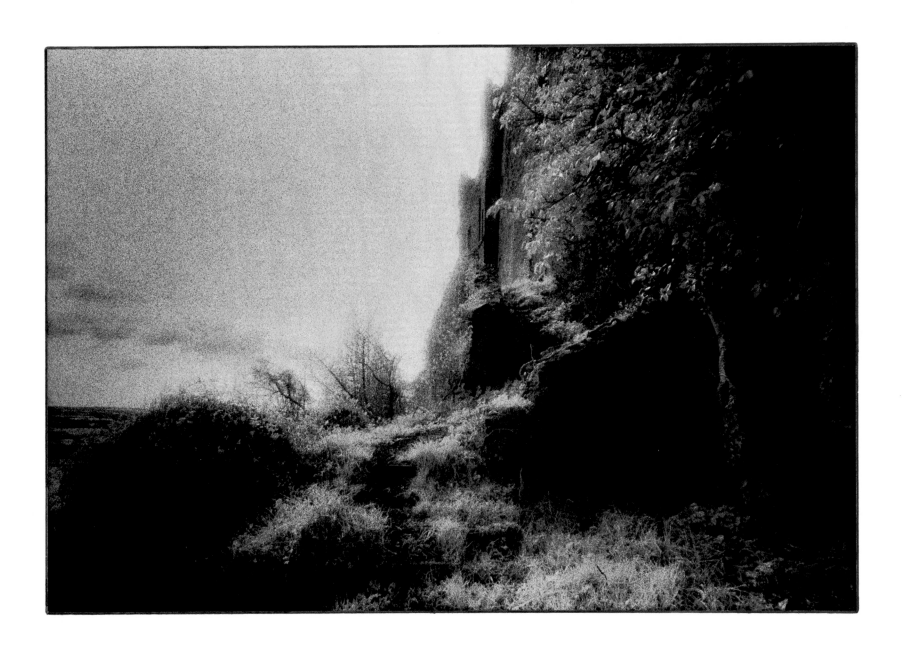

Mr. Godwin's Palace of Damp.

Dromore Castle. Pallaskenry, County Limerick.
Built in 1867–70. Abandoned in the 1920s
during the Troubles.

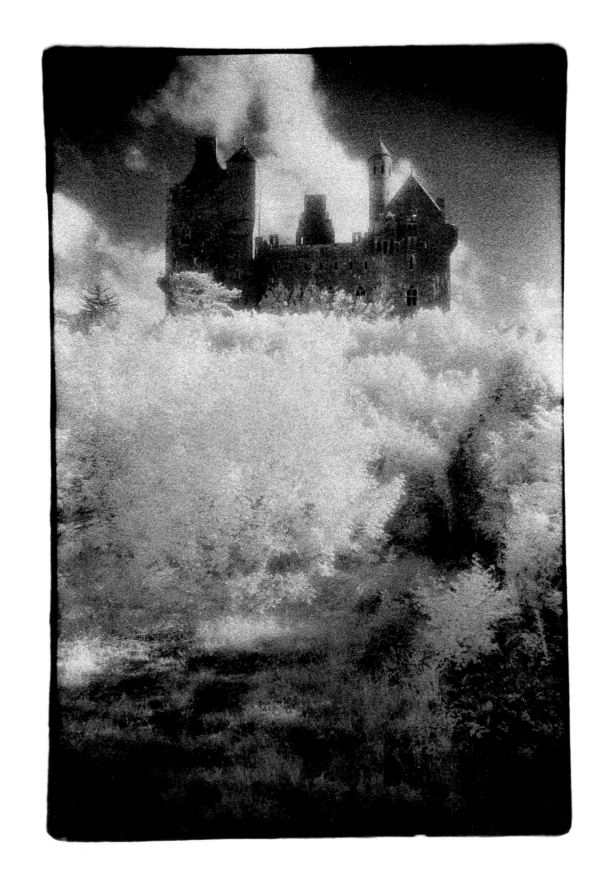

Acknowledgments

We would like to thank the following people for their help, information, hospitality, and inspiration, as well as the many landlords, farmers, innkeepers, and librarians of Eire whose help and kindness will not be forgotten: Count Alesandro degli Alessandre, The Three Sisters of Ardfry House, Col. and Mrs. Blackwood, Mr. Peter Blegrad, Miss Caroline Carey, Mrs. Mary Byron Casey, Mr. Willy Cody, Mr. and Mrs. John Cohane, Mr. and Madam Marcel Croes, The Earl and Countess of Dunraven, Messrs. Michael and Thomas Flahaven, Miss Fiona Ford, Mr. John and Lady Jennifer Fowler, Mr. John Gairdner, Mrs. John Gallagher, Mr. Thomas Garland, Mr. Shaun Gaul, Miss Penny Graham, Mr. Johnny Hennessey, Mr. R. William Higgins, Mr. and Mrs. Christopher Hindley, Mr. Thomas Kenney, Mr. Johnny Keyhoe, Mr. Alan and Lady Vivienne Lillingston, Miss Mary Ann Linden-Skeggs, Mrs. Donna Long, Mr. and Mrs. George Loudon, Mrs. Dermot McCalmont, Mr. Michael McCalmont, Mr. John McCann, Mrs. Nora Moran, The Earl and Countess of Mount-Charles, Mr. Taf Namerg, Mr. John Nankivell, Miss Angela Neville, Mr. Nicholas Nicholson, Sir Hugh and Lady Nugent, Mr. Gerard O'Brien, D.L.I.S., Messrs. Ruan and Oscar O'Lochlainn, Mr. Percy Paley, Col. Power, Mrs. Gervas Power, Mr. Piers Rogers, Major and Mrs. Patrick Rome, Mr. Patrick Ryan, Mrs. Robin Saythers, Sergeant Scully, Father Slattery, Mr. and Mrs. Ian Spence, Mr. and Mrs. T. Alan Staunton, Miss Jane Storr, Count Trolle-Bunde, The Old Coachman of Waterston House, 1978, and Mrs. Beryl Windsor.

Bibliography

Ancient Legends, Mystic Charms and Superstitions of Ireland, Lady Jane Wilde. London, 1888.

Burke's Guide to Country Houses, Vol. 1, *Ireland*, Mark Bence-Jones. London, 1978.

Castles of Ireland, C. L. Adams. London, 1904.

Castles of Ireland, Brian De Breffny and George Mott. London, 1977.

"The Curse of Cromwell," *The Collected Poems of William Butler Yeats*. London, 1950.

"The Empty Grandeurs of Ardo," *Country Life Annual*, Mark Bence-Jones. London, 1968.

Guide to Kilkenny City and County, P. M. Egan. Kilkenny, 1884.

Historical and Topographical Notes, etc. on Buttevant, Castletownroche, Doneraile, Mallow, and Places in Their Vicinity, Vol. 3, J. G. White. Cork, 1905–16.

The Houses of Ireland, Brian De Breffny and Rosemary Ffolliott. London, 1975.

The Illustrated Guide to the Blackwater and Ardmore. 1840.

Illustrated Guide to the City of Limerick and Antiquities in Its Neighbourhood. Hodges, Figgins, and Co. Ltd., Limerick.

Irish Archaeological Journal, Vol. 18 (5th series), 1908.

The Journal of the Cork Historical and Archaeological Society, Vols. 70–71, 1965–66.

The Journal of the Galway Archaeological and Historical Society, Vol. 1, no. 1; Vol. 2, no. 1.

The Journal of the Kildare Archaeological Society, Vol. 2, 1898.

The Last Earls of Barrymore, 1769–1824, John R. Robinson. London, 1894.

Limerick: Its History and Antiquities, Ecclesiastical, Civil, and Military, From the Earliest Ages, M. Lenihan. Dublin, 1884 and 1886.

Lost Demesnes, Edward Malins and The Knight of Glin. London, 1976.

North Munster Antiquarian Journal, Vols. 3–5, 1942–48.

North Munster Studies, Etienne Rynne, ed. Limerick, 1967.

Old Kilkenny Review, no. 4, 1951; no. 21, 1969.

Sketches in Carbery, County Cork, Daniel Donovan. Dublin, 1876.

Some Celebrated Irish Beauties of the Last Century, F. Gerard. London, 1895.

Some Georgian Houses of Limerick and Clare, S. Stewart and R. Herbert. 1949.

South Westmeath, Farm and Folk, Jeremiah Sheenan. Dublin, 1978.

Topographical Dictionary of Ireland, Vol. 2, Samuel Lewis. London, 1837.

Wonders of Ireland, Eric Newby and Diana Petry. London, 1969.

A NOTE ON THE TYPE

The text of this book has been set on the Monotype in a type face named Aldine Bembo. The roman is a copy of a letter cut for the celebrated Venetian printer Aldus Manutius by Francesco Griffo and first used in Cardinal Bembo's *De Aetna* of 1495—hence the name of the revival. Griffo's type is now generally recognized, thanks to the researches of Mr. Stanley Morison, to be the first of the old face group of types. The companion italic is an adaption of the chancery script type designed by the Roman calligrapher and printer Lodovico degli Arrighi, called Vincentino, and used by him during the 1520s.

This book was composed by A. Colish, Inc., Mount Vernon, New York. The photographs were printed in two colors by Rapoport Printing Corporation, New York, New York, using their Stonetone Process. It was bound by A. Horowitz & Sons, Fairfield, New Jersey.

Designed by Dorothy Schmiderer